Local Sanctuary

Dylan Punke

Copyright © 2011 Dylan Punke

All rights reserved.

ISBN: 1463506031
ISBN-13: 978-1463506032

To those with foresight to preserve. To those who cultivate for generations they will never know.

Life has allowed me the luxury of travel since I can remember. If I am not in movement, I am often dreaming about the possibility of movement. My mind often dreams of exotic and unknown territories, quite alluring and distracting. From the Grand Canyon to the mighty Amazon River, Angel Falls to the Himalayas, the Pyramids to the Great Wall; there is a ceaseless tempt. Recently my journey of being on the road hasn't brought me to these international treasures but instead to a quiet local nature preserve. This preserve is often overlooked, rarely on a map, and never in a guidebook, but is still tended by dedicated hands and persevering minds.

Rediscovering and exploring this preserve, I am learning a lesson that I have resisted; to love the land that is beneath my feet. I thought I knew this land that I grew tall in but I have barely scratched the surface. Growth occurs from the preserve's allowance of intimate pondering, meditation, reflection, and recreation that has long been hidden by ambitious pursuits. Upon every entry, it renews, regenerates, and reestablishes the natural connection that is so often deprived. A grounding yet paradoxically uplifting reality emerges, instead of an alluring and distracting dream. I can enter with the foggiest of minds and leave with clearness that once seemed unreachable.

The tranquility found in the woods and the flow of the river has taught me to reconsider beauty. I am slowly understanding that beauty is not only reflected in the natural world, but we as humans being a part of the natural world, are capable of having that beauty illuminate within. I am seeing that beauty is everywhere and it is not necessary to roam the earth to find such. The following photographs are my attempt at capturing some of this beauty from my personal journey, but are not intended to replace the physical realm of being in its presence.

It is not my hope that this particular place is flocked to in great numbers or that the photographs in it are attempted to be replicated. I hope that you are inspired to stop in your own lands to gain your own fresh approach and appreciate that which is in front of you. To be willing to re-envision what has patiently been waiting all along underneath your feet and within you. Much as it is rare to daily worship in the grandest of temples it is also rare to daily trek in the world's international treasures. So whether it be a sprawling oasis in the middle of plowed earth or the tiniest of parks dwarfed by urban density, I hope you find your own Local Sanctuary.

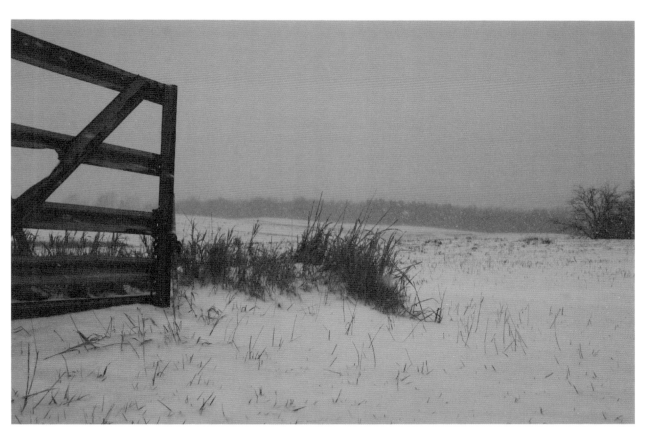

Winter Gate

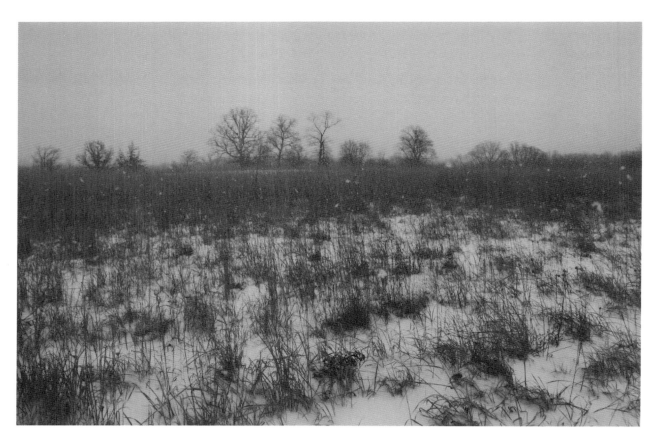

Prairie Snow

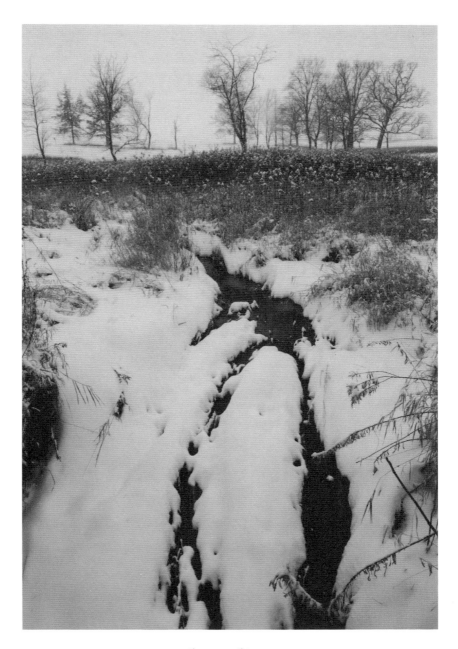

Snowy Stream

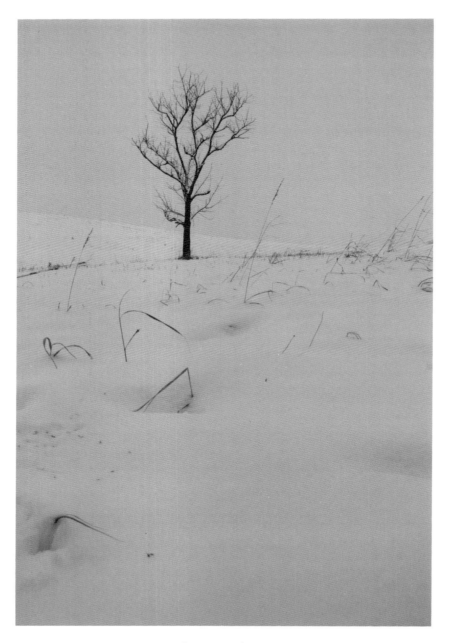

Grayish Winter

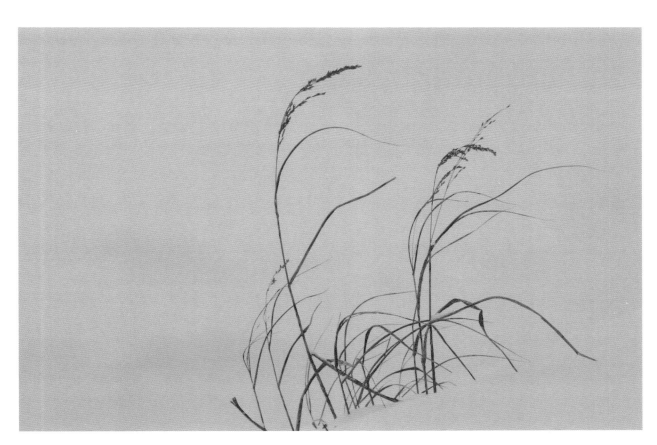

Hillside Nudes

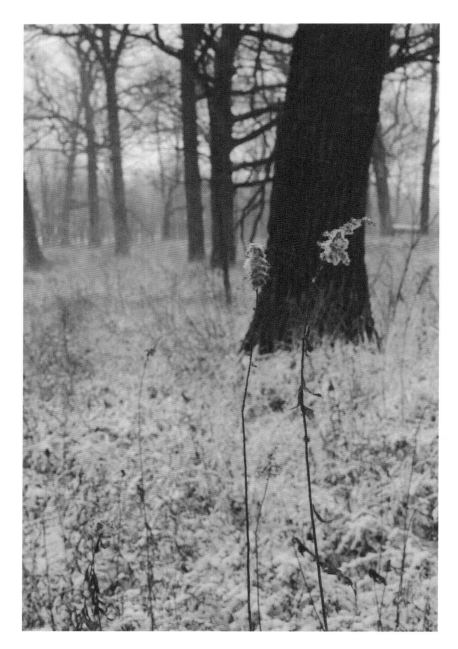

Snowy Dance

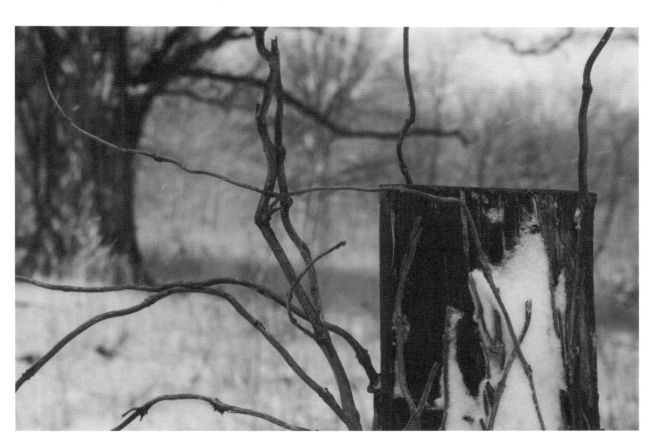
Winter Vines

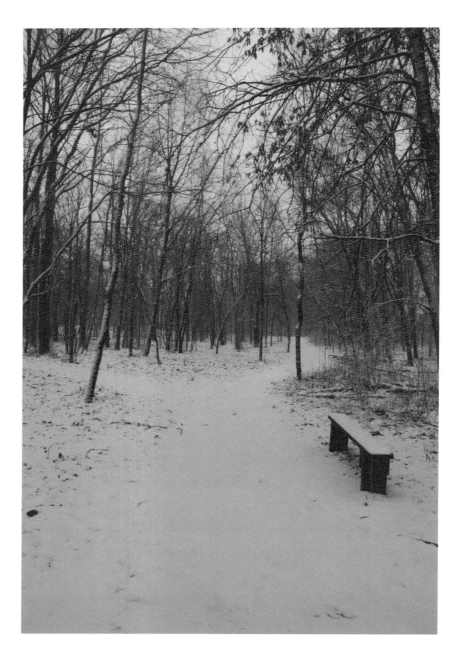

Winter, Y

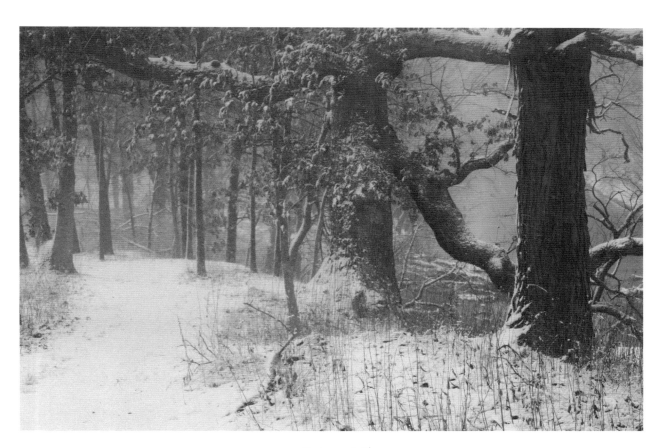

Winter Walk

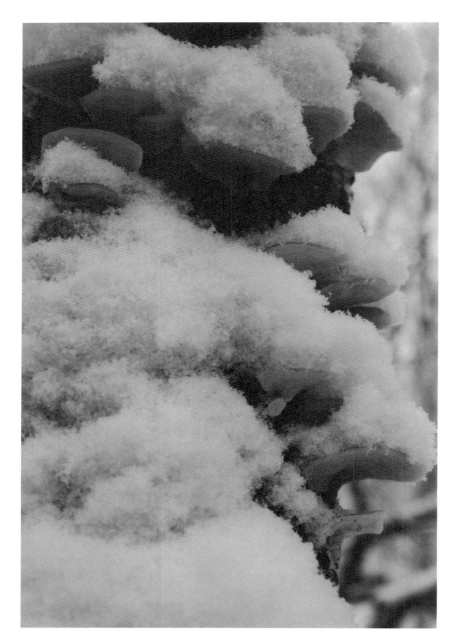

Tiered Powder

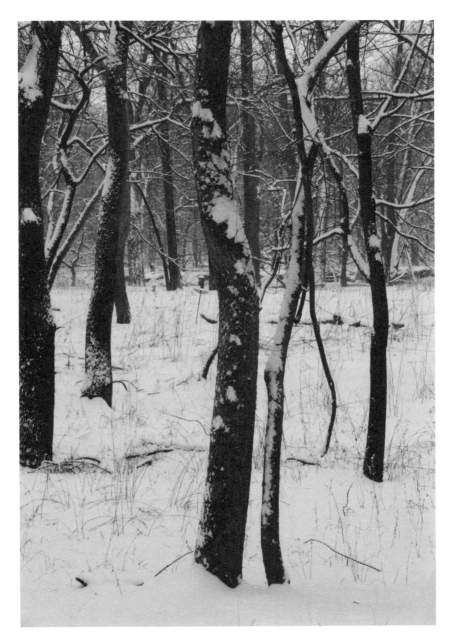

Lowland Winter

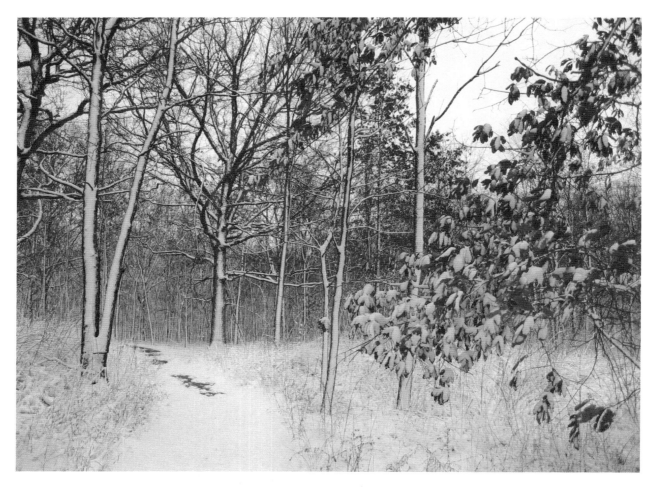

Unbeaten Path

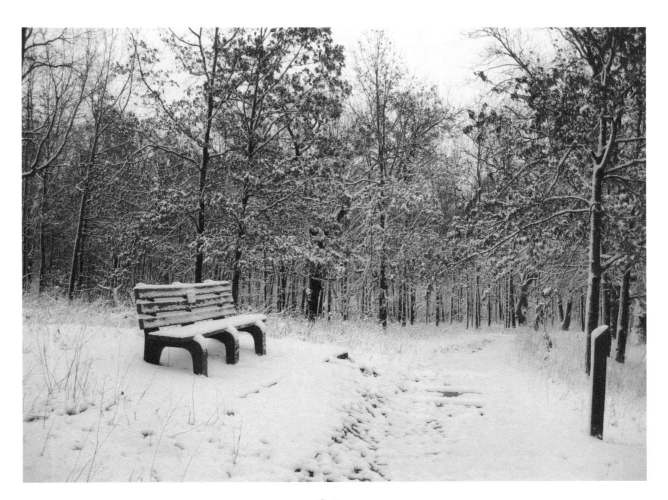

Refuge

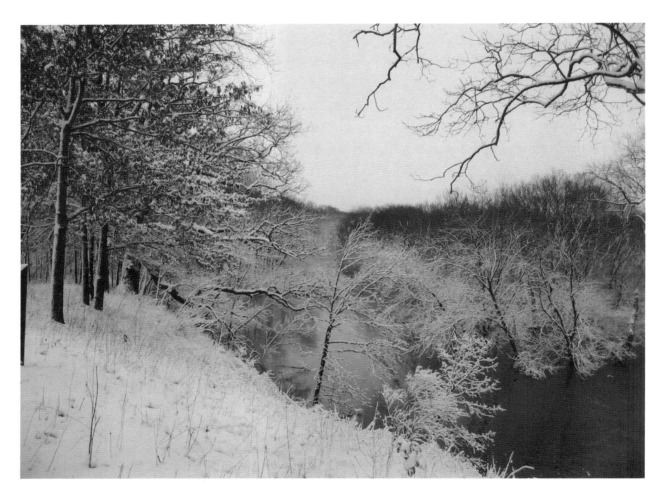

Mackinaw

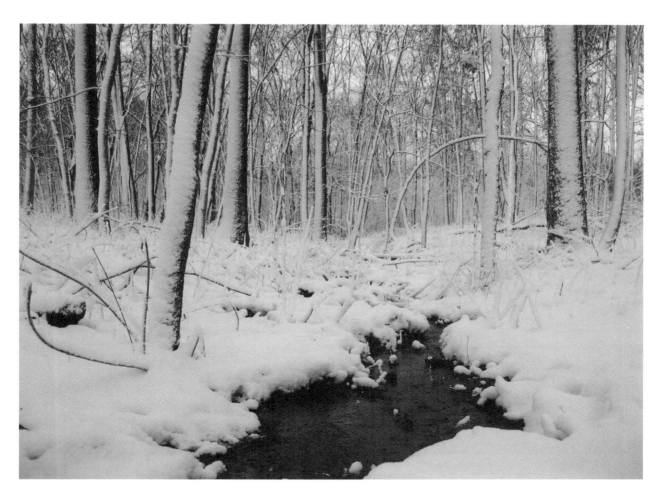

Chilly Creek

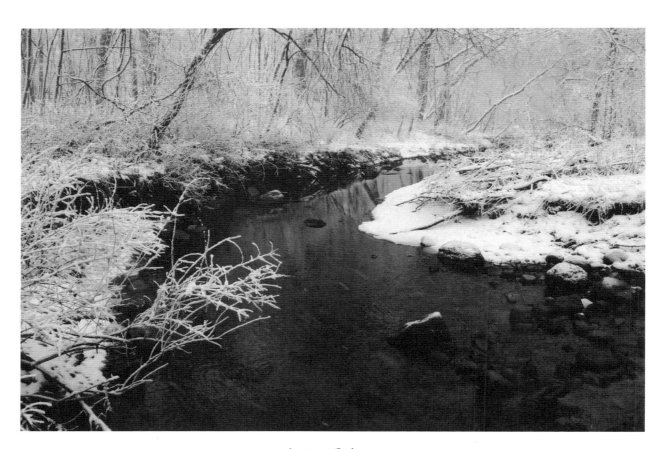

Winter Tributary

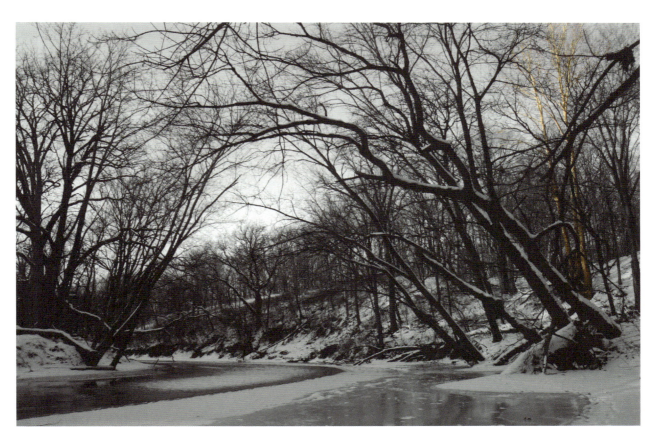

Winter Cast

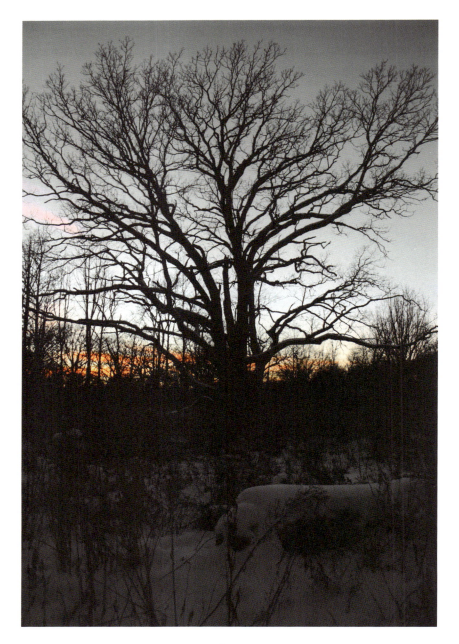

Aura

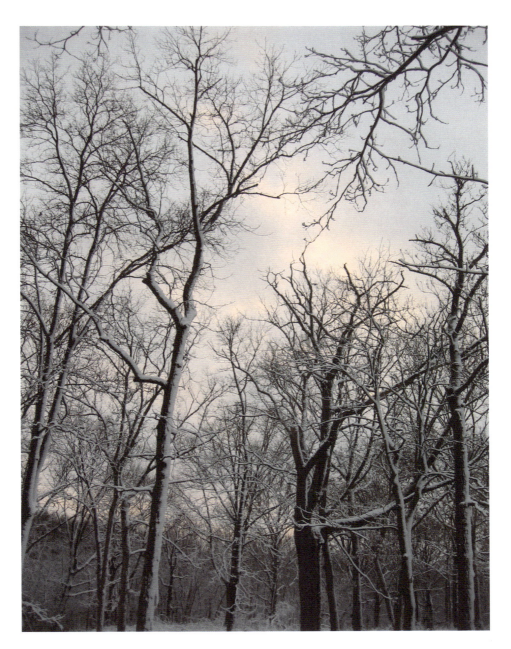

Wintry Dusk

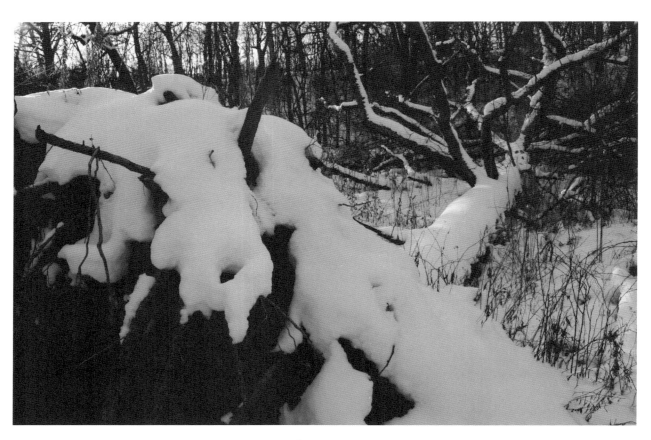

Fallen Giant

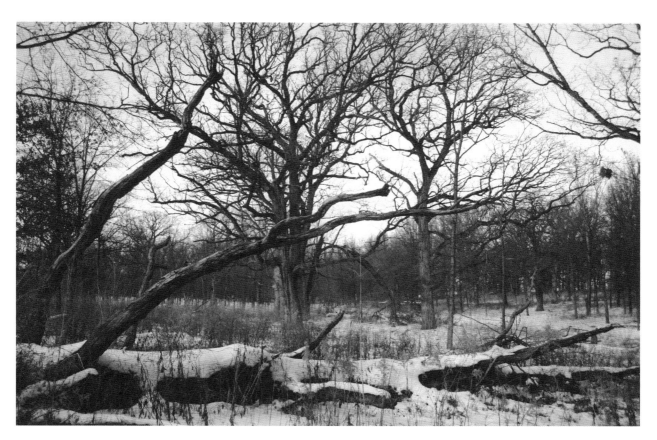

Raised Branches

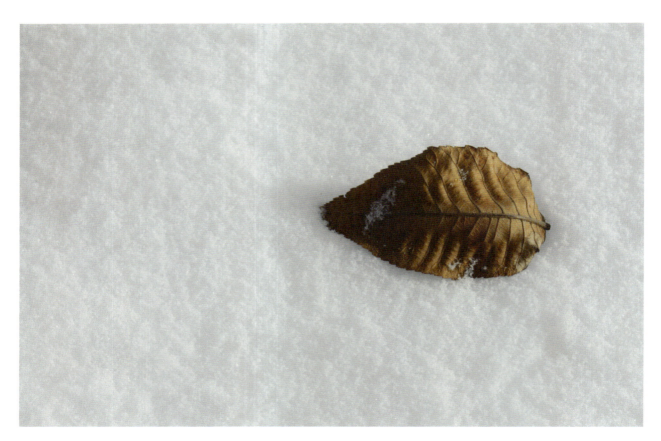

Cool Leaf

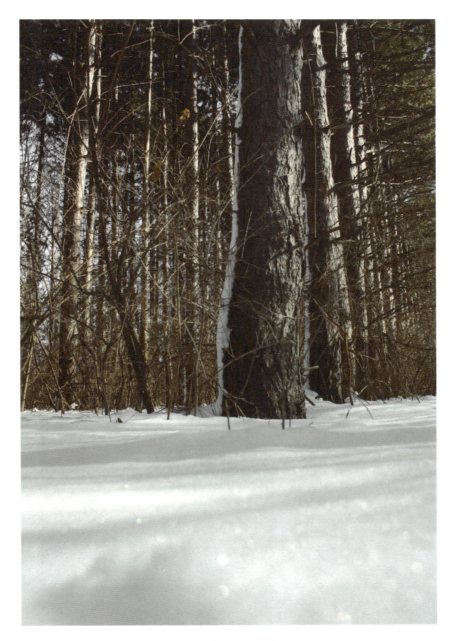

Lighting Pines

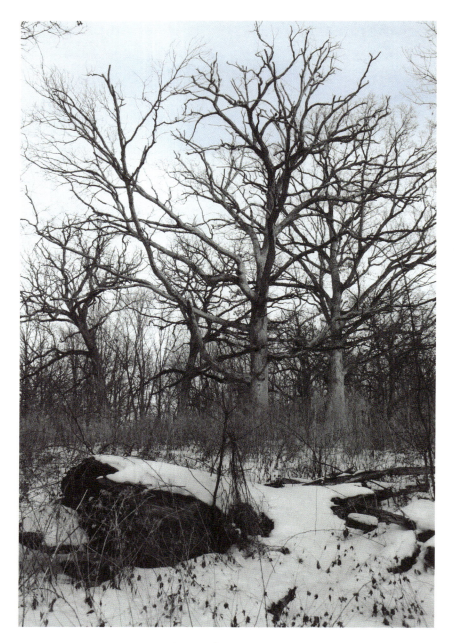

Soft Winter Blues

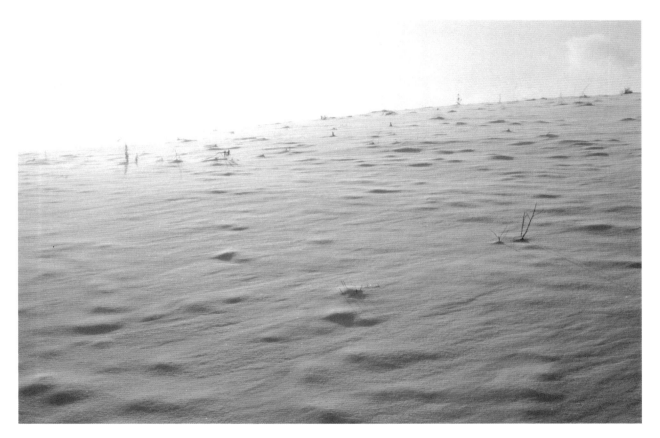

Winter Warmth

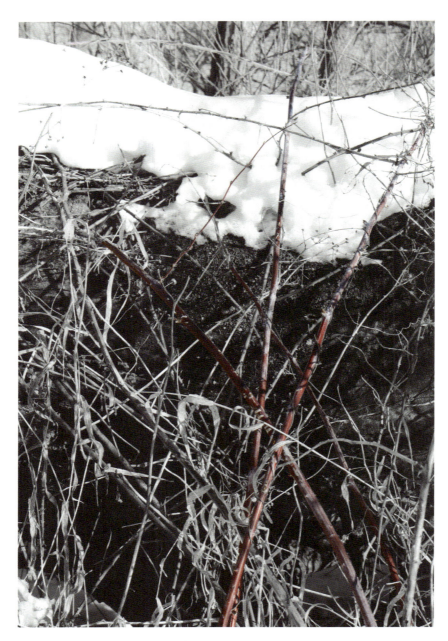

Winter Crossing

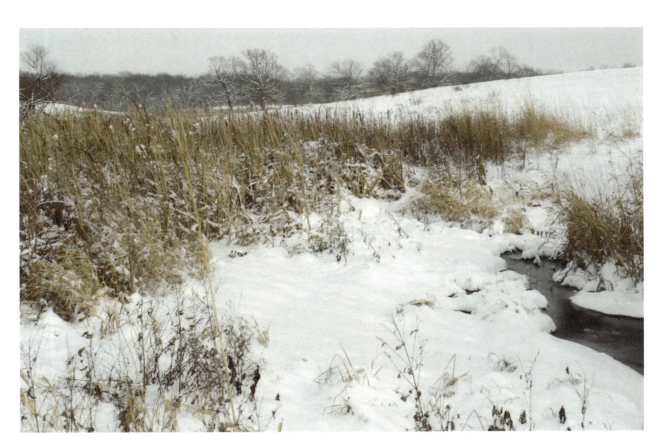

Winter Clearing

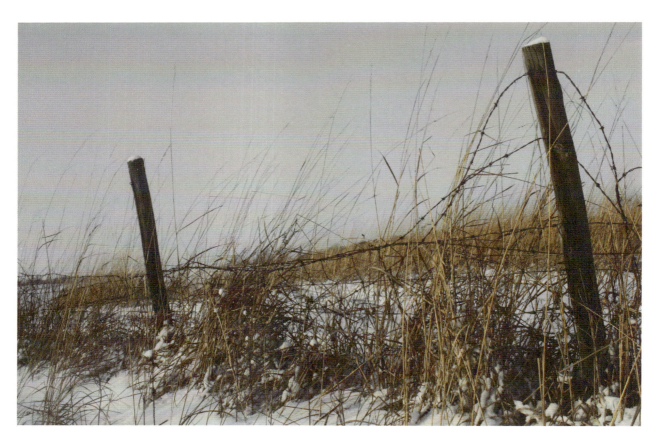

Prairie & Fence

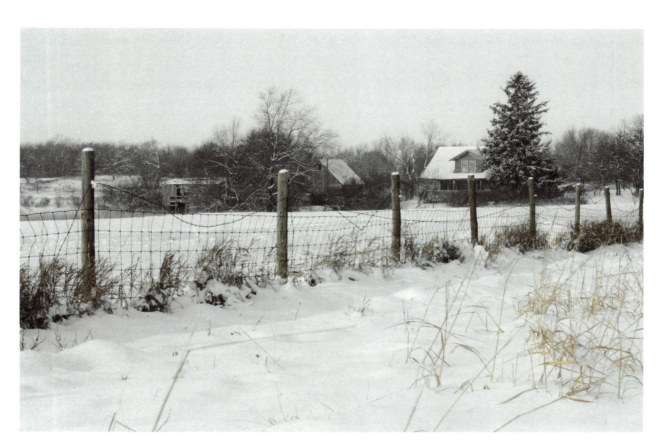

Quiet Neighbors

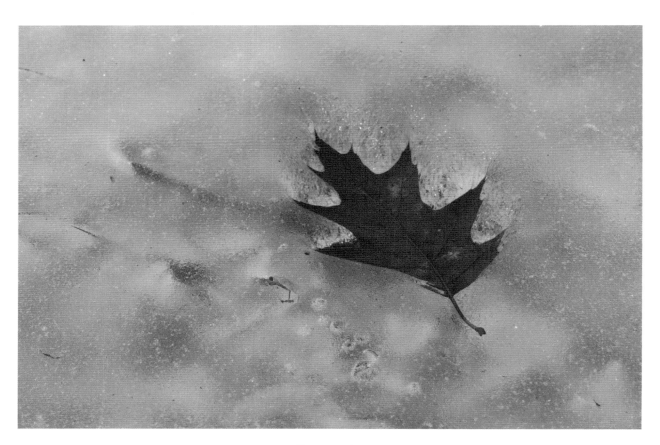

Impression

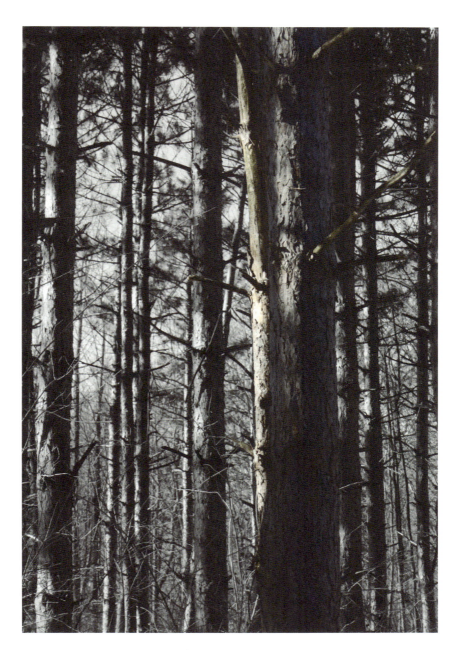

Vertical Tangent

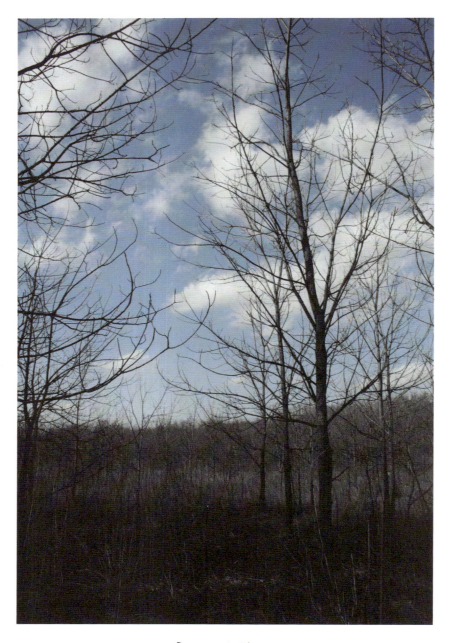

Dormant Blues

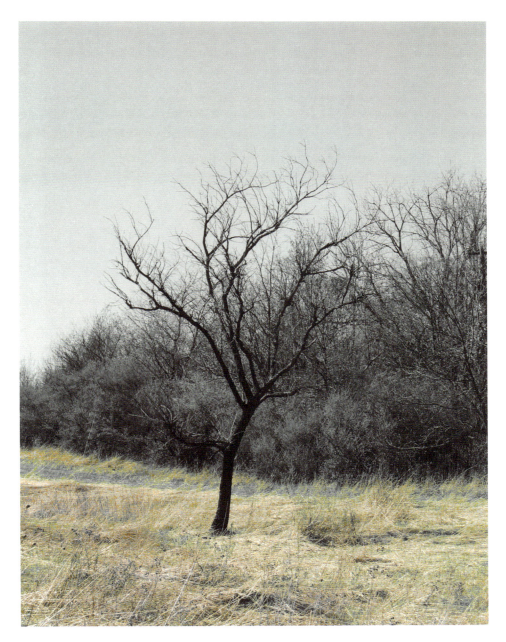

Golden Grass

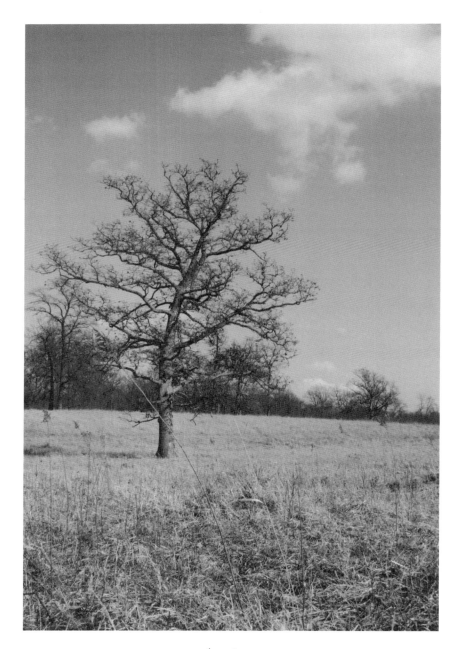

Leanings

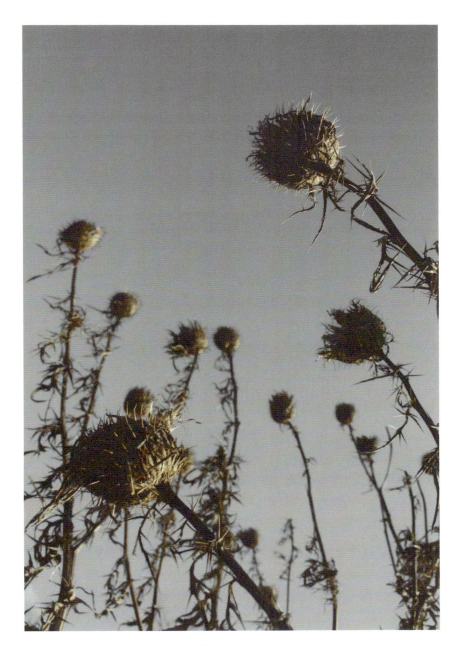

Assemblage

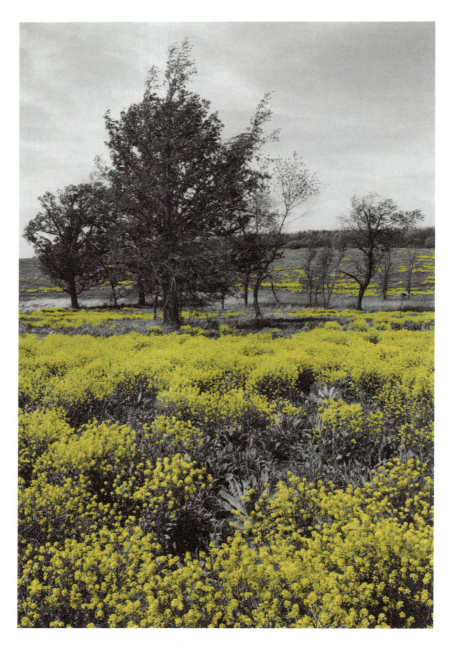

Yellow Prairie I

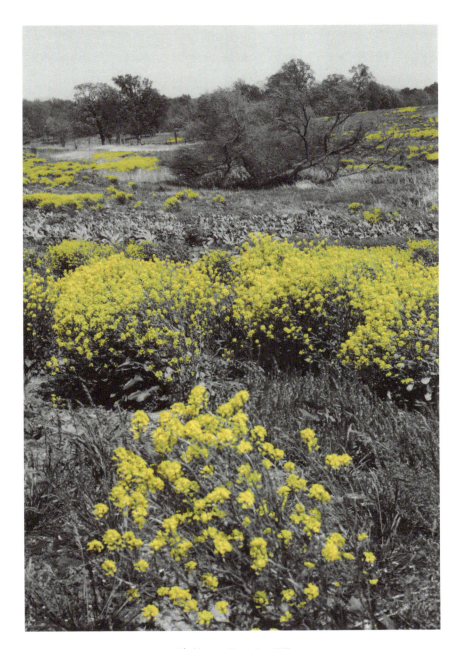

Yellow Prairie II

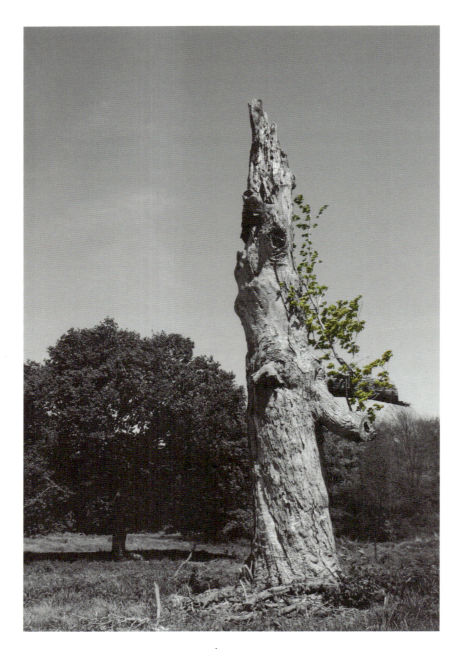

Legacy

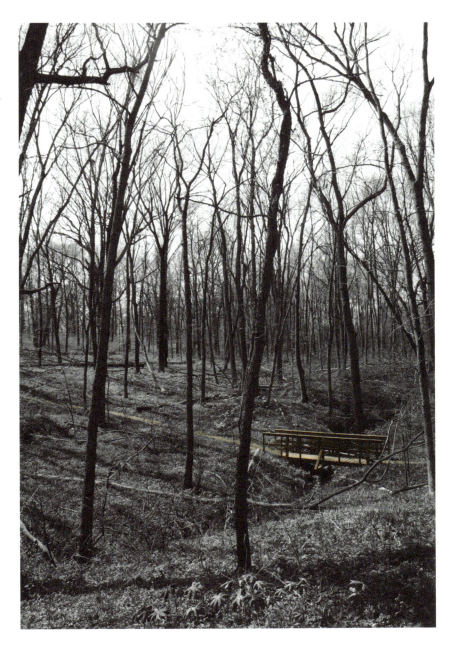

Crossing Barren Trees

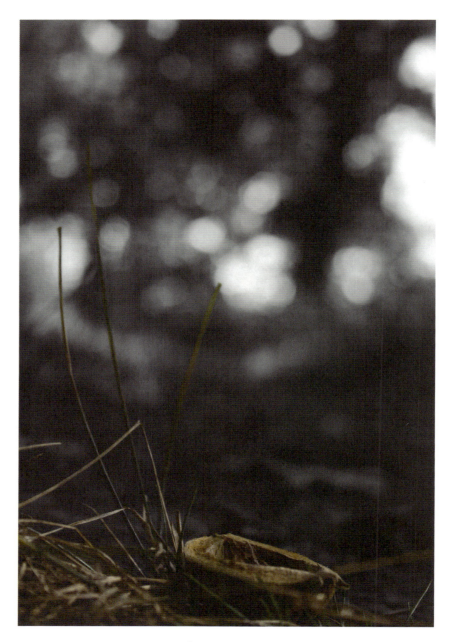

Out of Shell

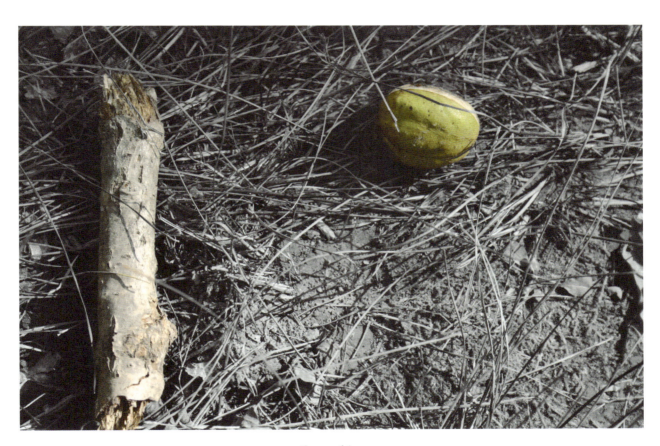

From Above

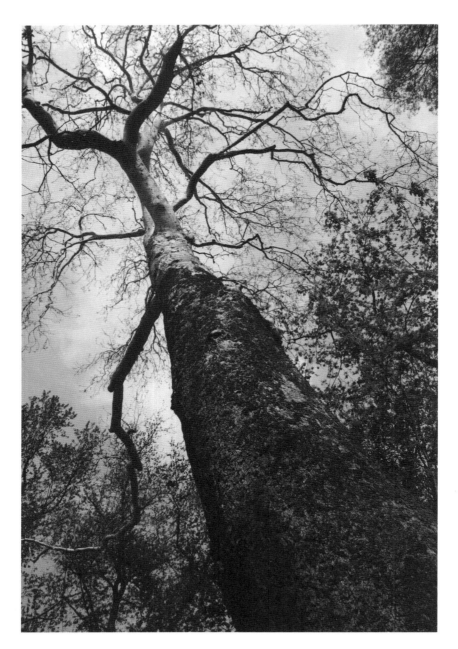

Majestic

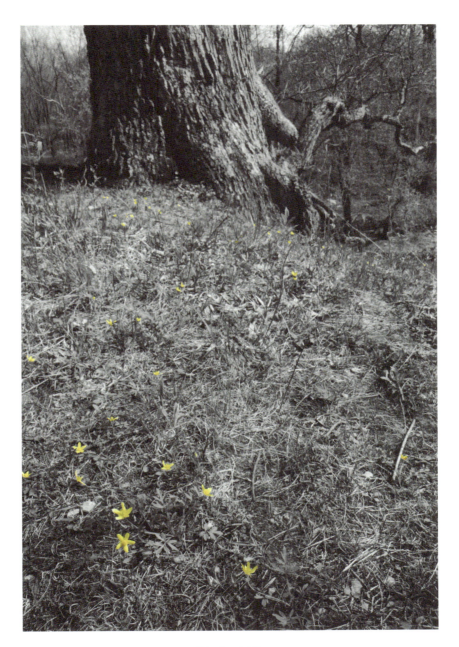

Distant Kin

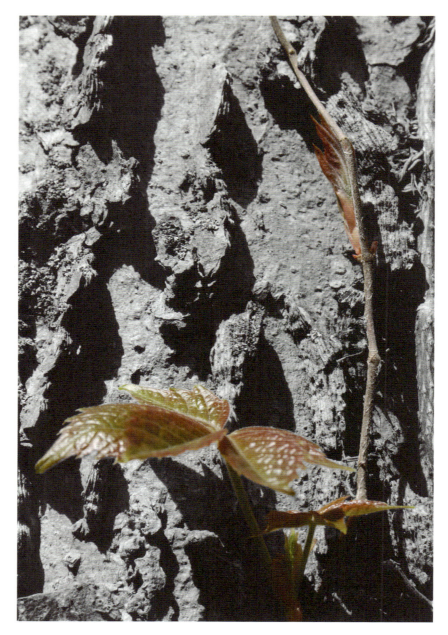

Sprouting Lineage

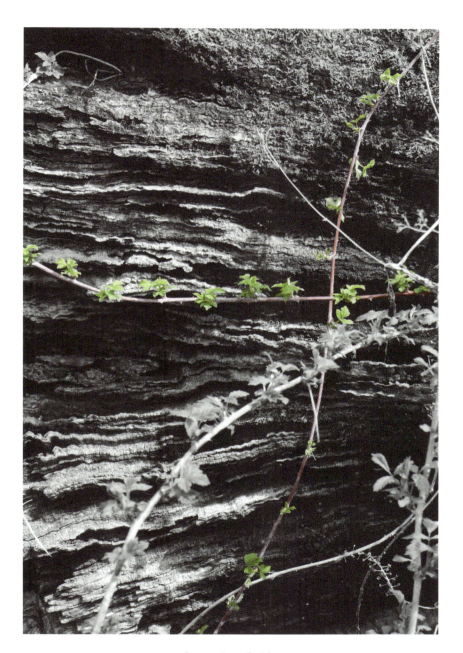

Crossing Paths

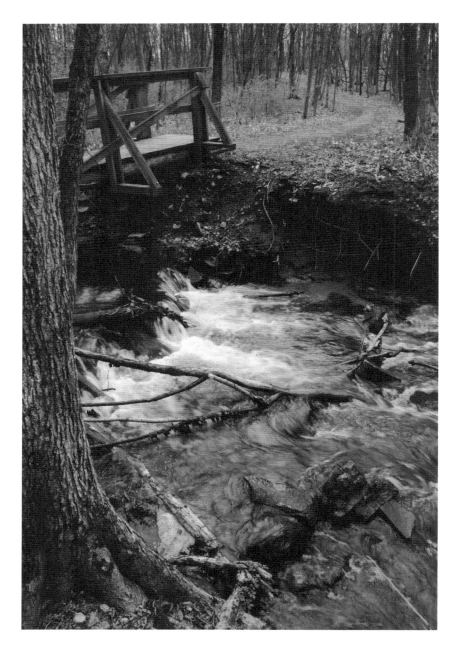
Creek Crossing

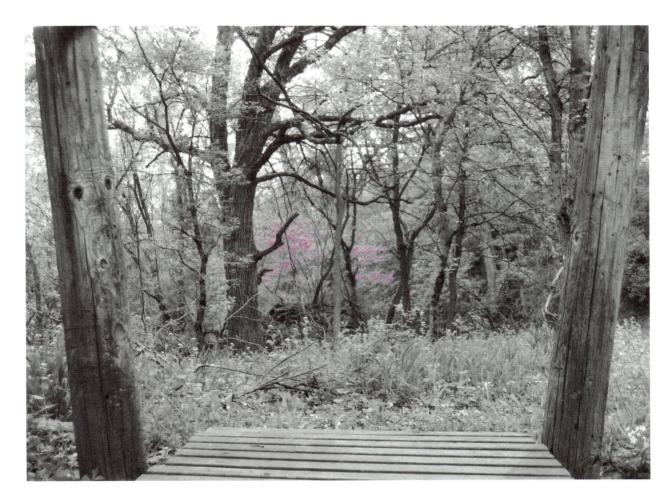

Bridge to Beauty

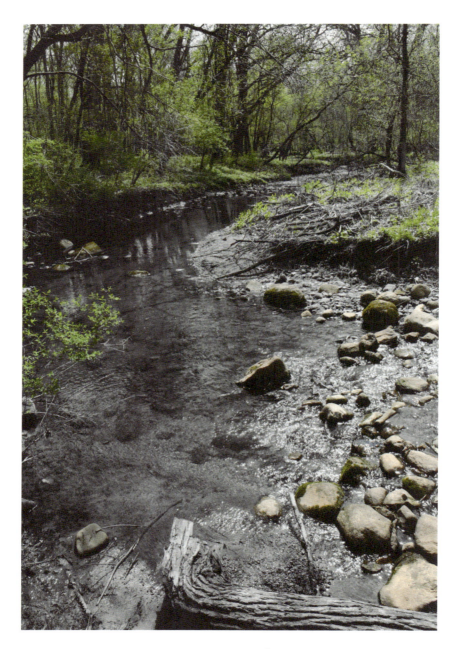

Spring Creek

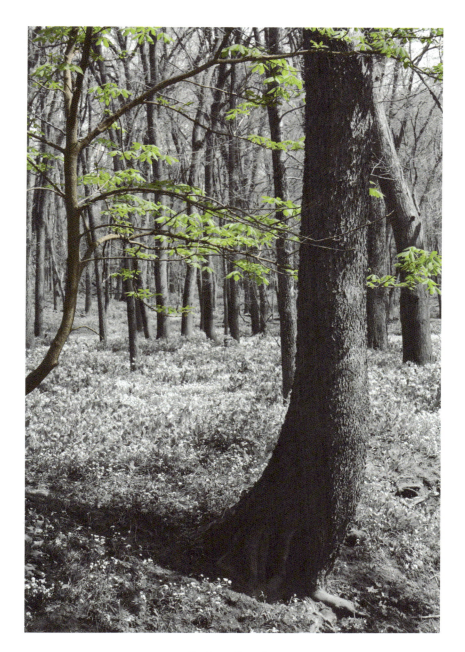

Spring Greeting

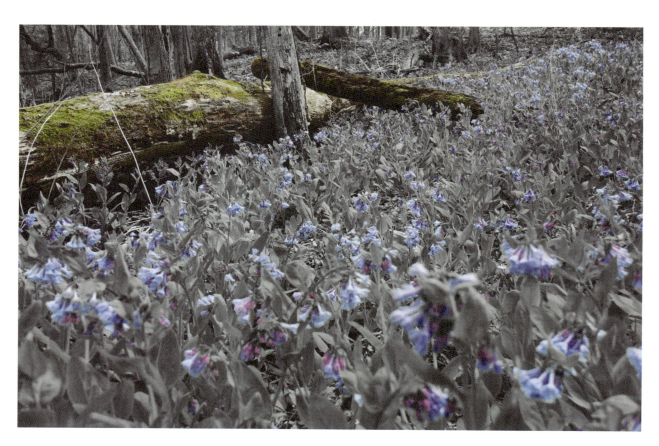

Blue Comfort

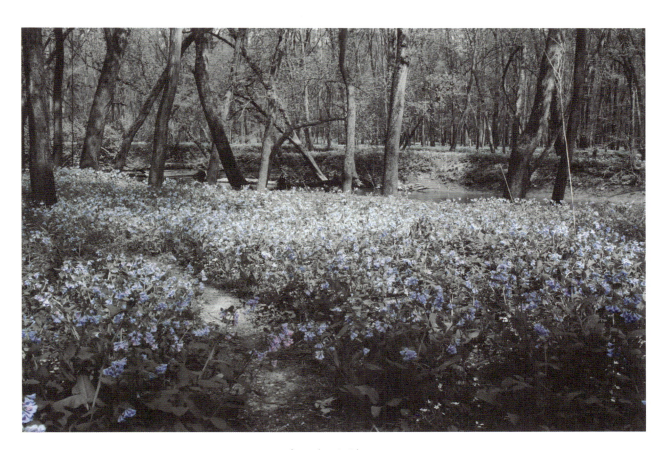

Lowland Blues

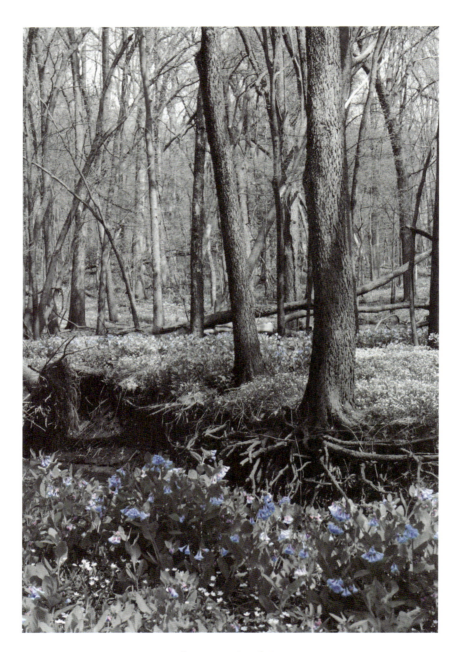

Rooted Bluebells

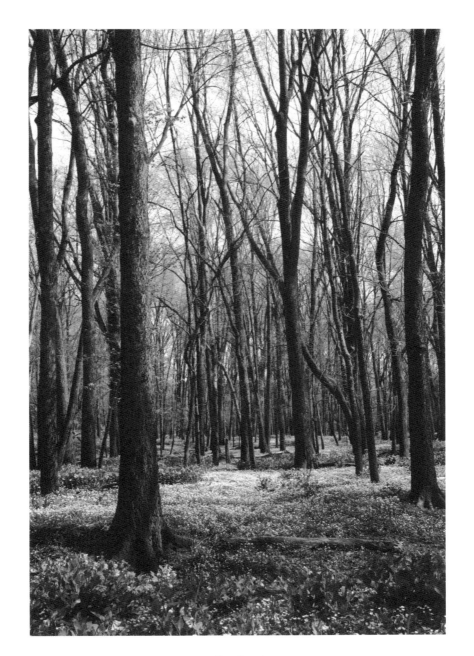

Enchant

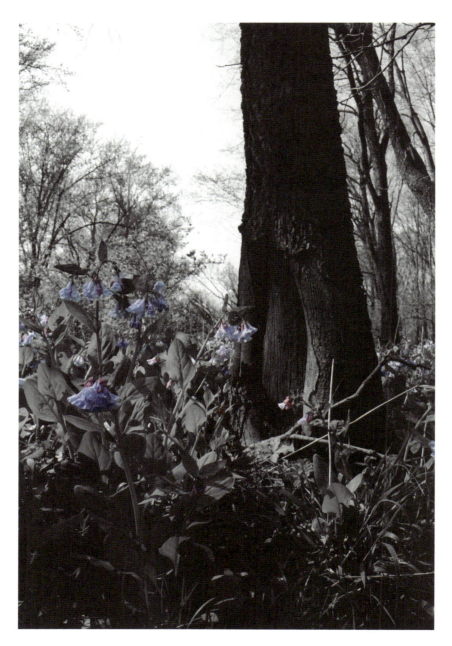

Shaded Blues

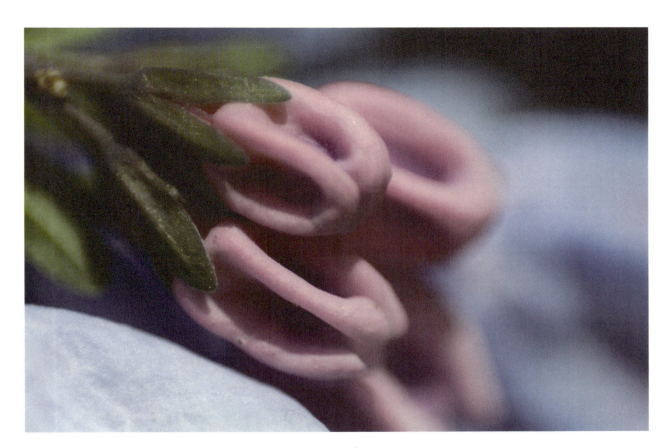

Intimate Virginia

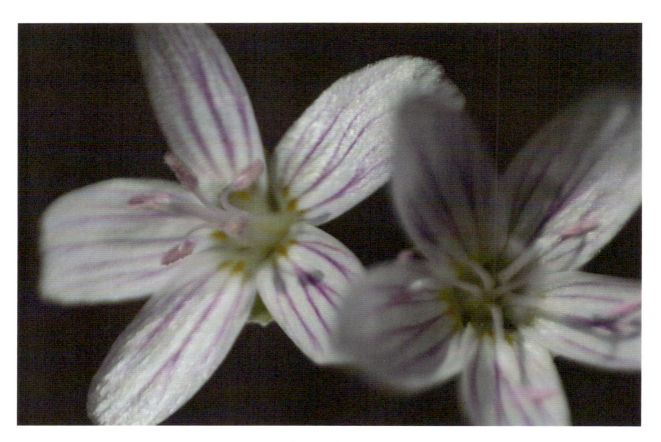

Spring Beauty

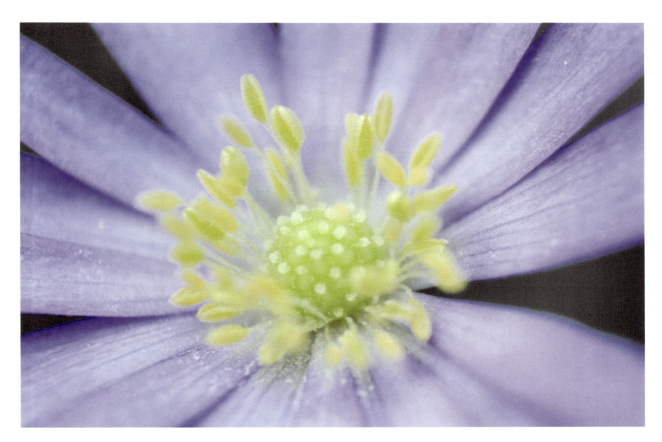

Centrifugal Burst

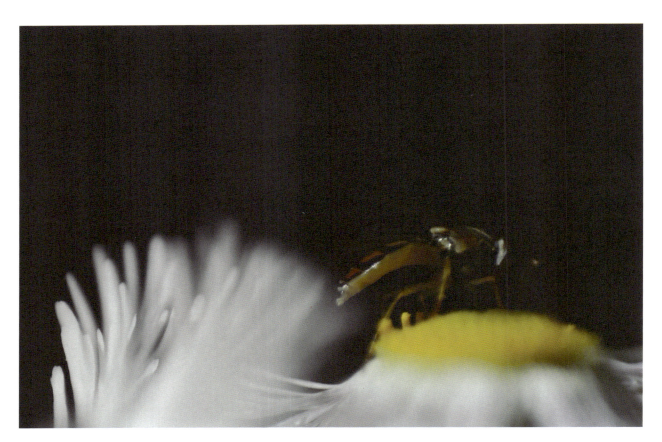

Abuzz

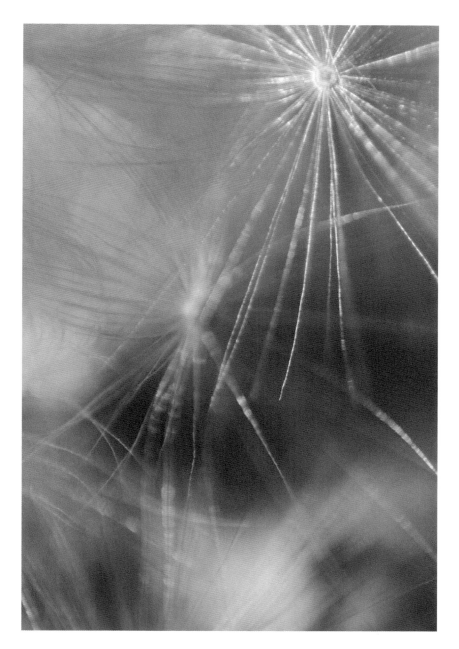

Glimmer

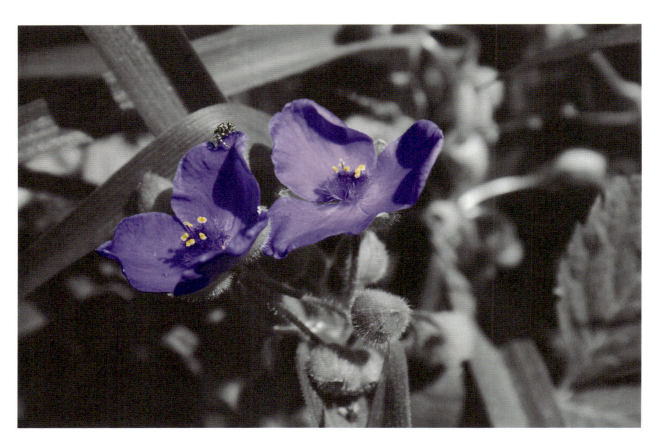

Small Friends

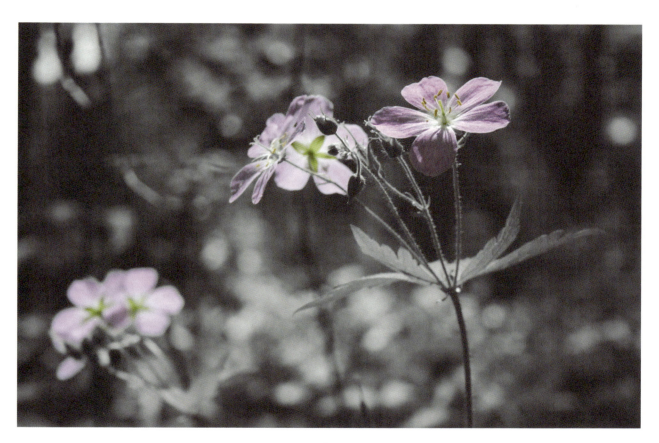

Quiet Gatherings

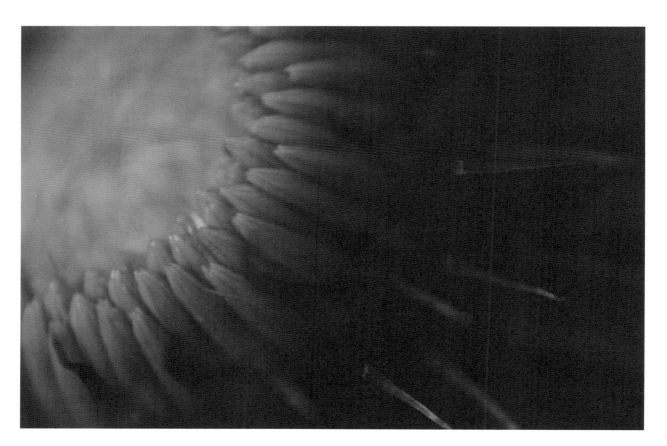

Muted Beauty

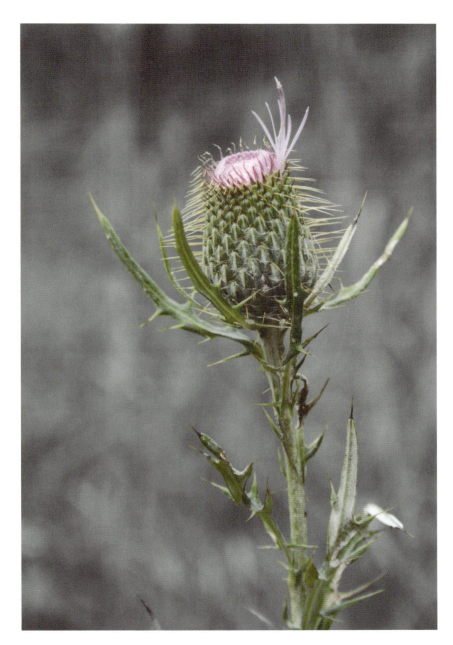

Guarded Beauty

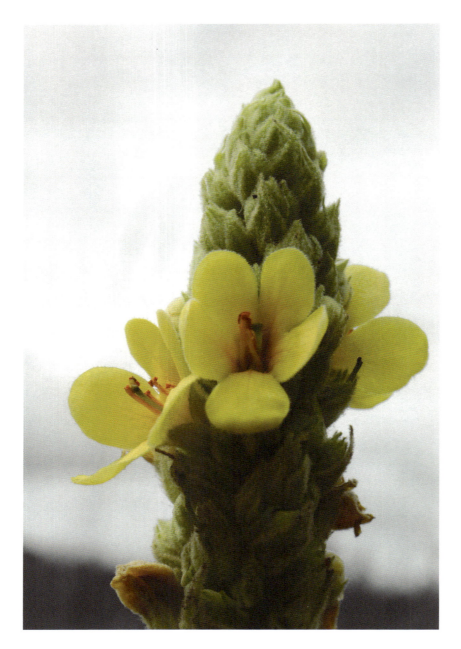

Prairie Cone

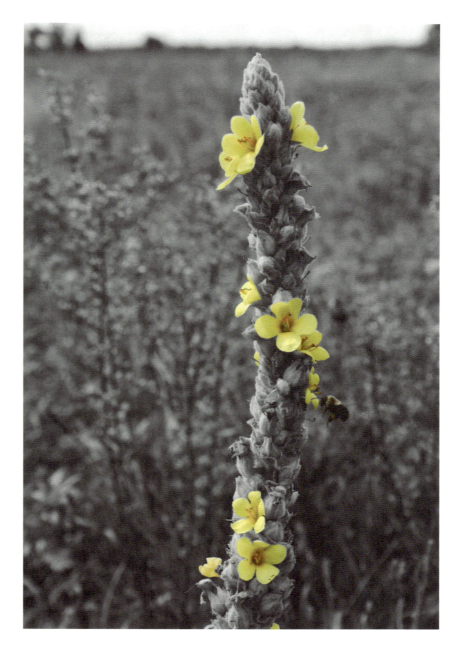

Pollen Buzz

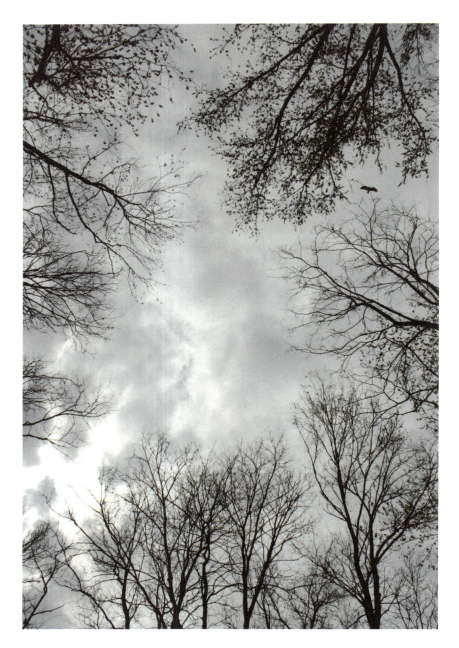

Upwards

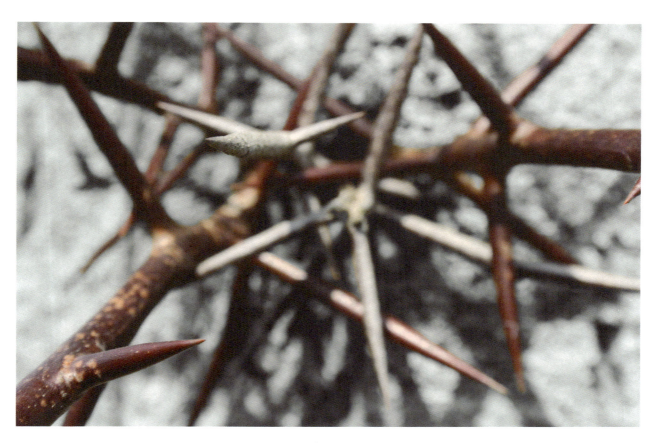

Thorns

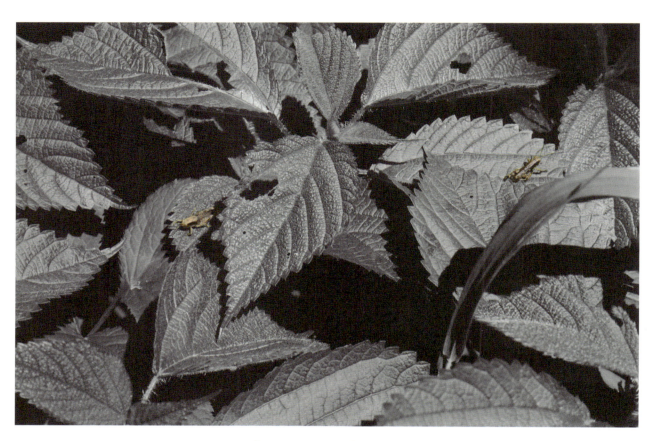

Faux Summer Raindrops

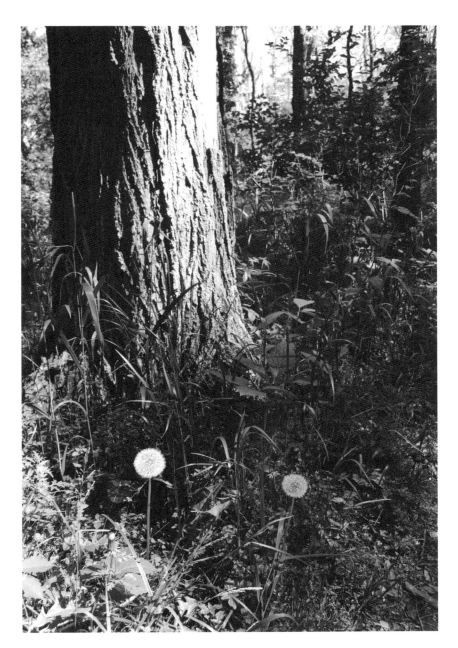

Small Ideas

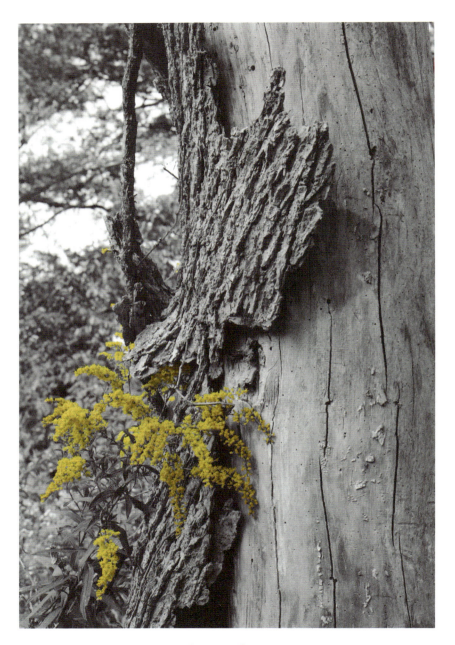

Yellow Tufts

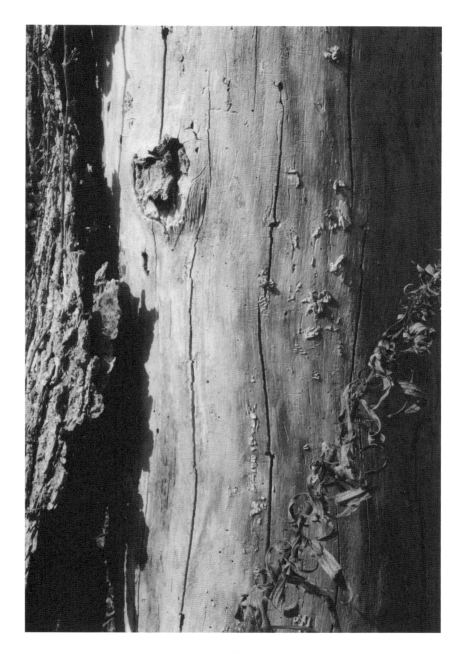

Solo Journey

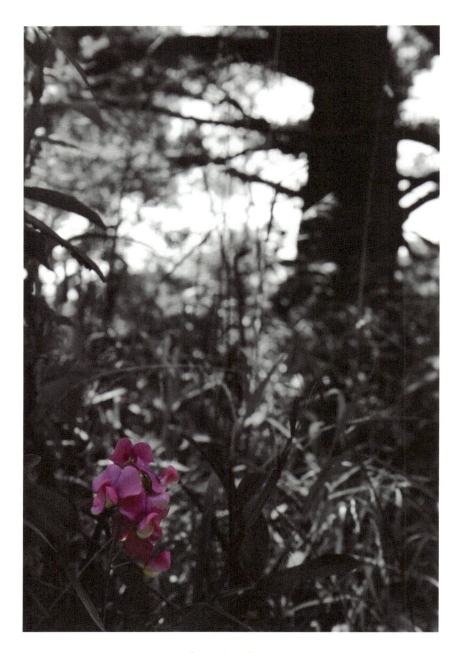

Crimson Base

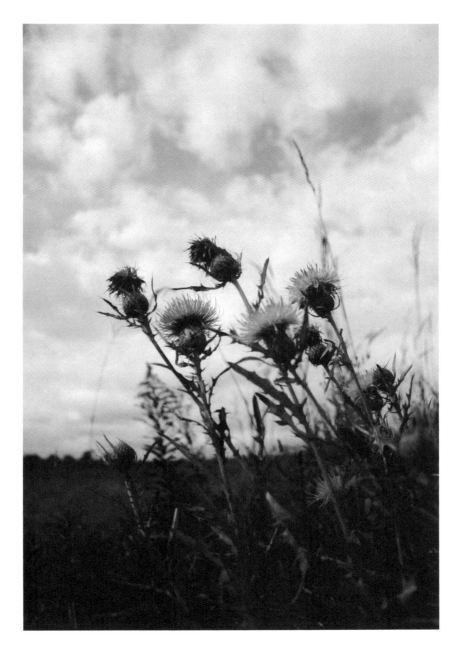

Thistle

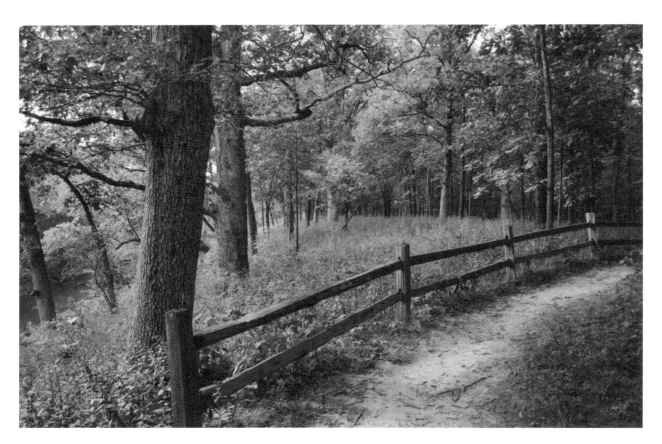

Parkland

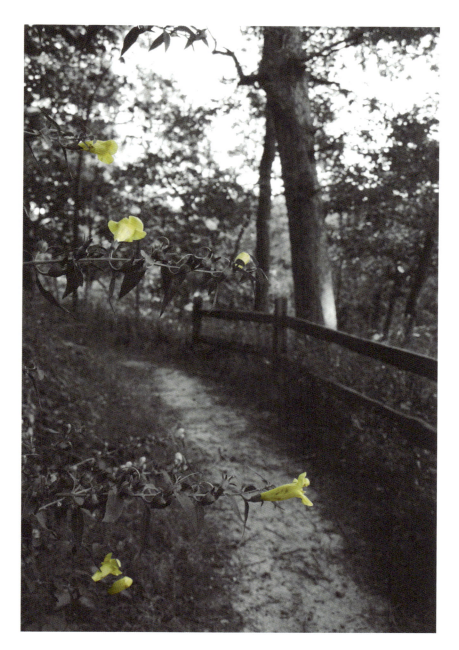

Delicate Path

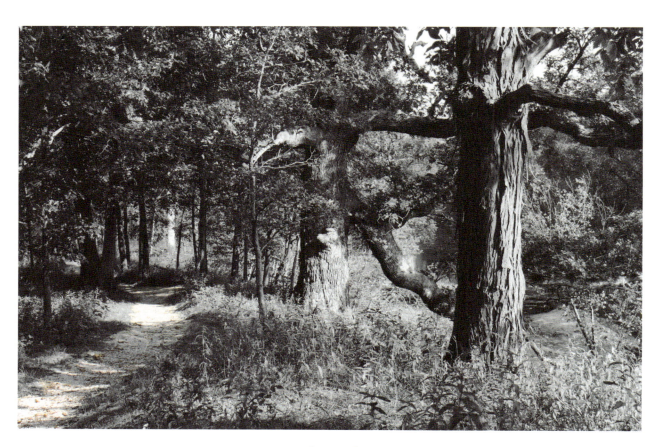

Parkland Trail

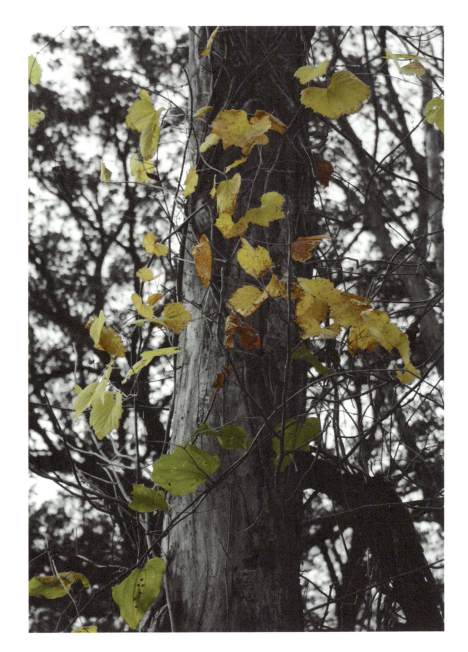

Convert

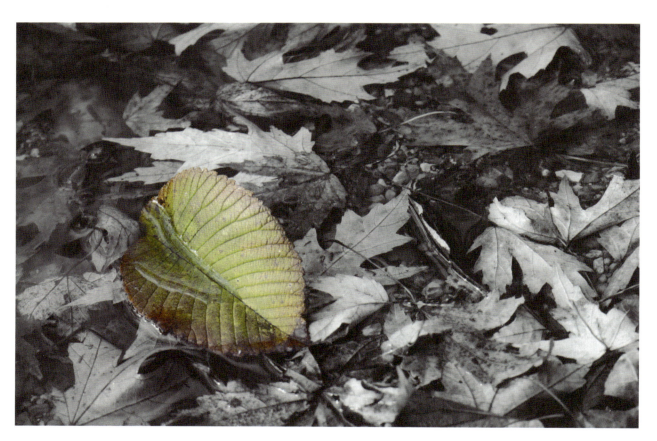

River Leaf

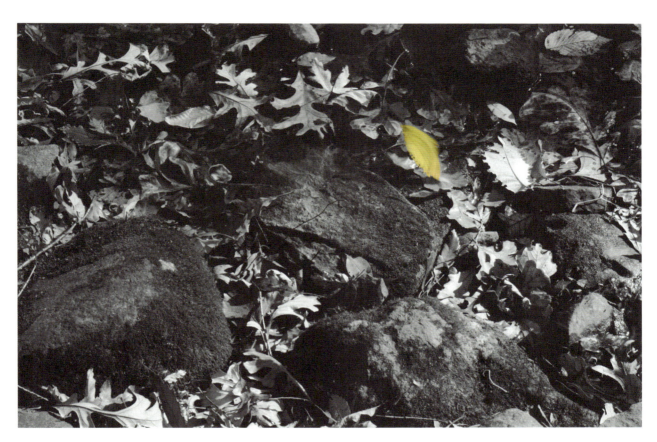

Swift

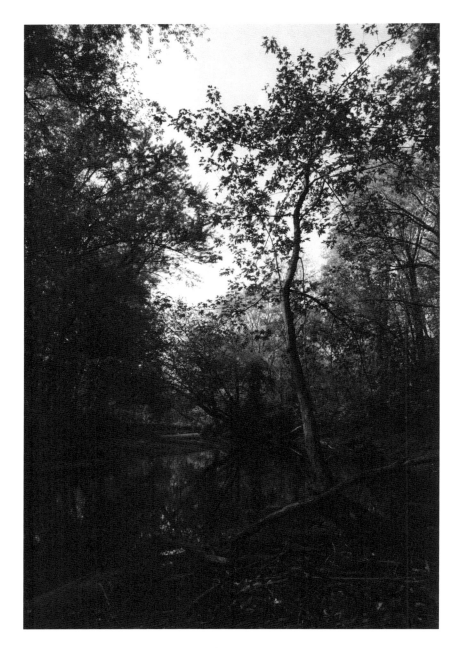
Meander

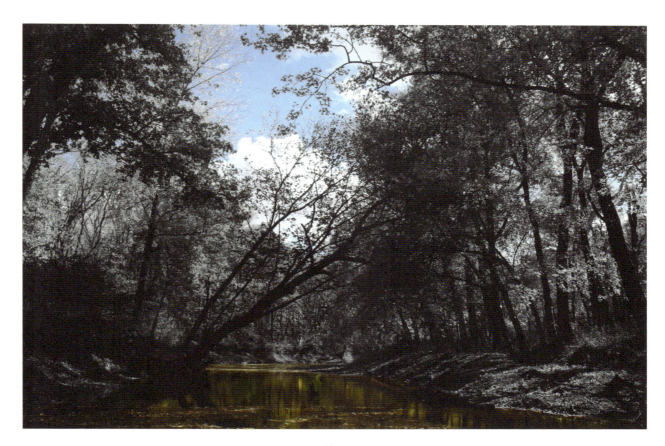

Flow

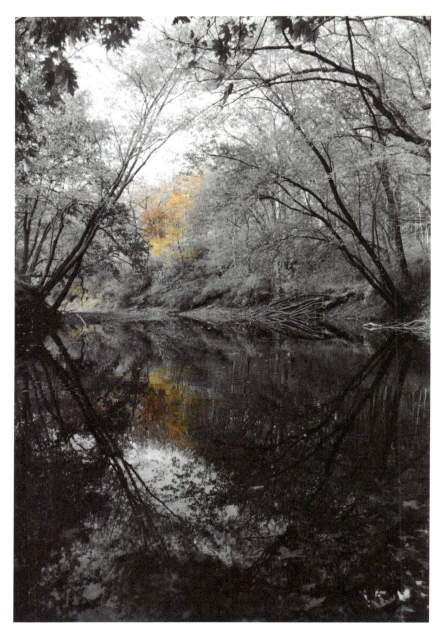

Mackinaw Fall Reflection

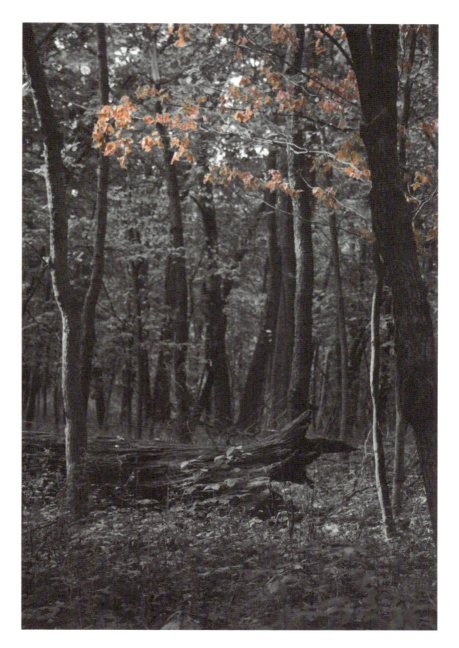

Faint Fall

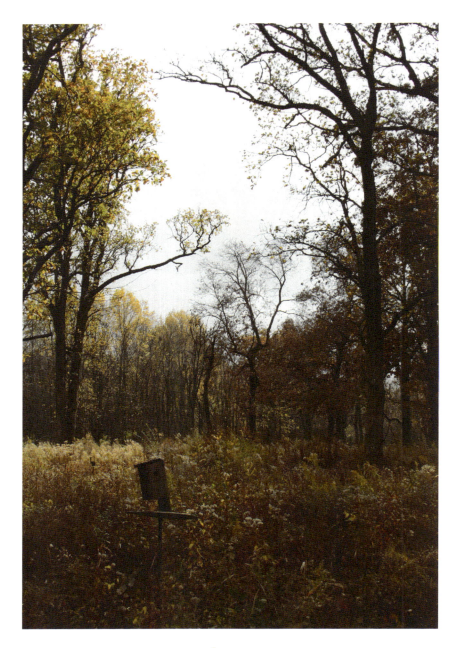

Autumn

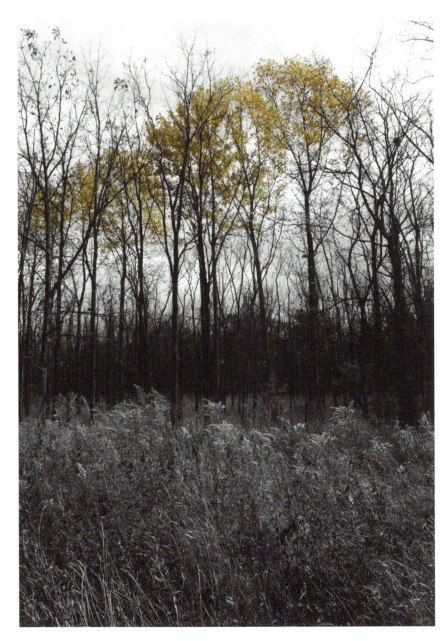

Elevated Autumn

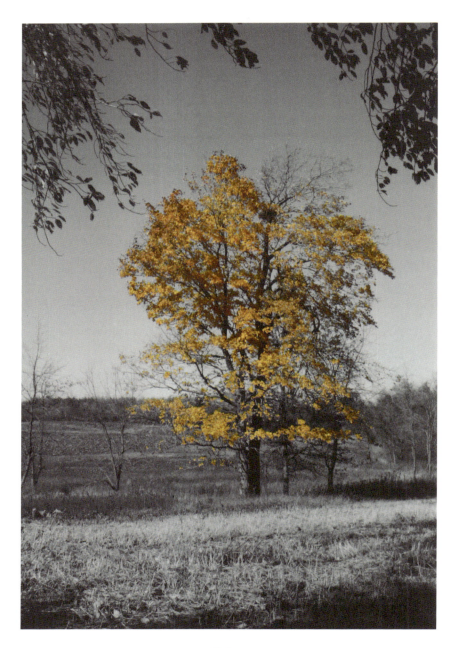

Aglow

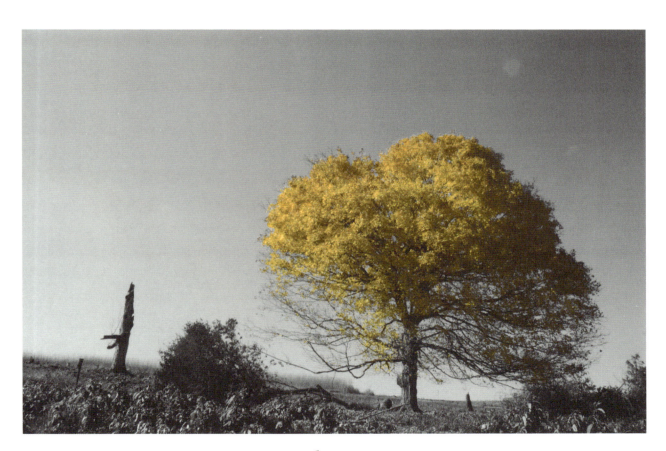

Radiance

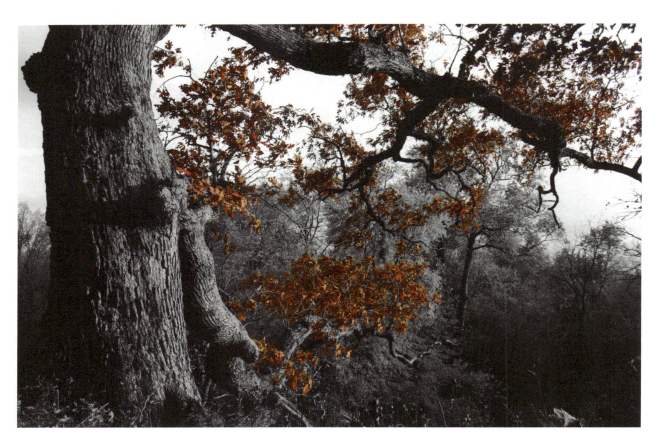

Autumn Oak

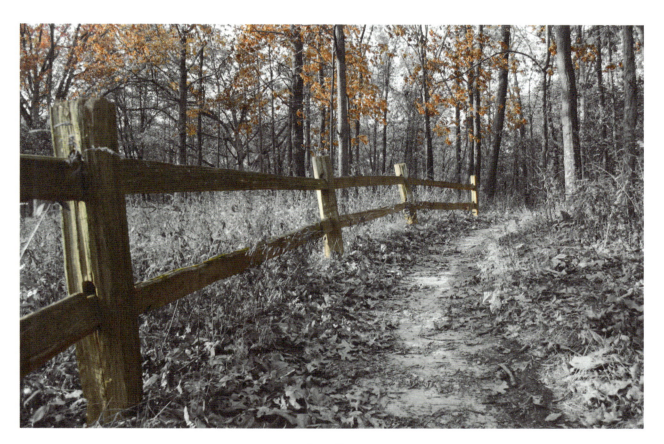

Fall Fence

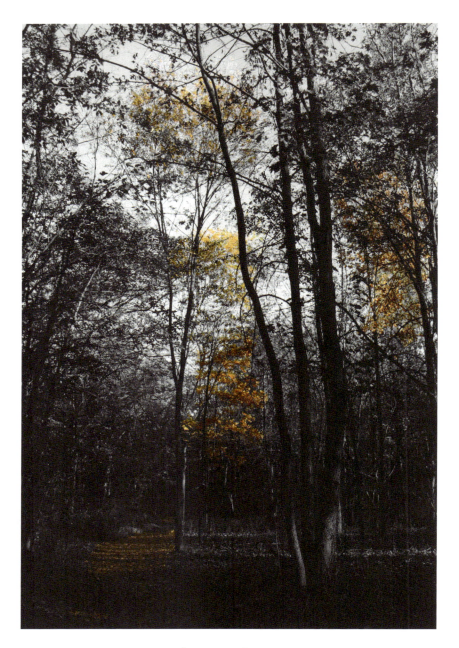

Autumn Morning

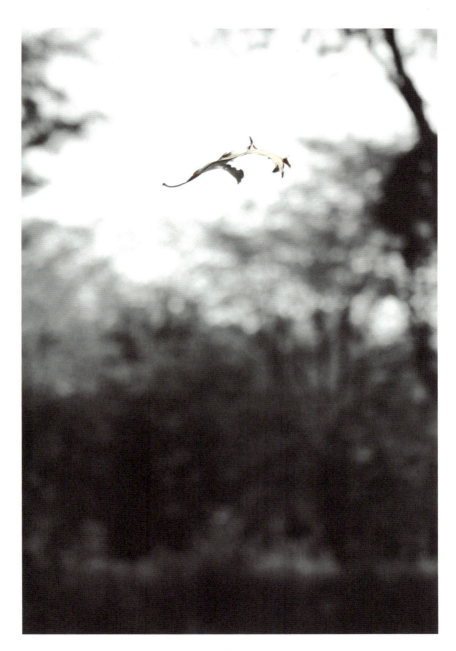

Waft

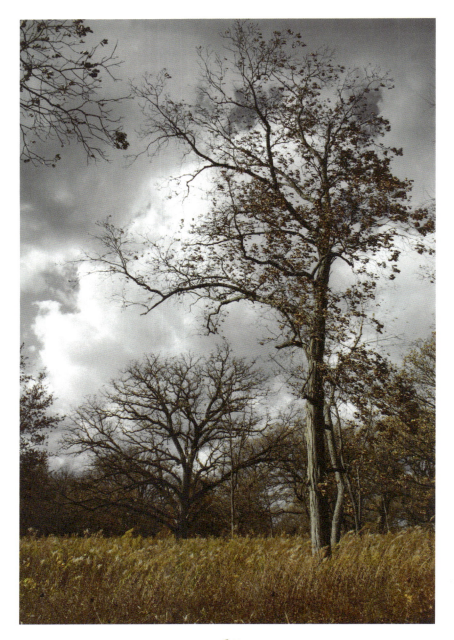

Fall

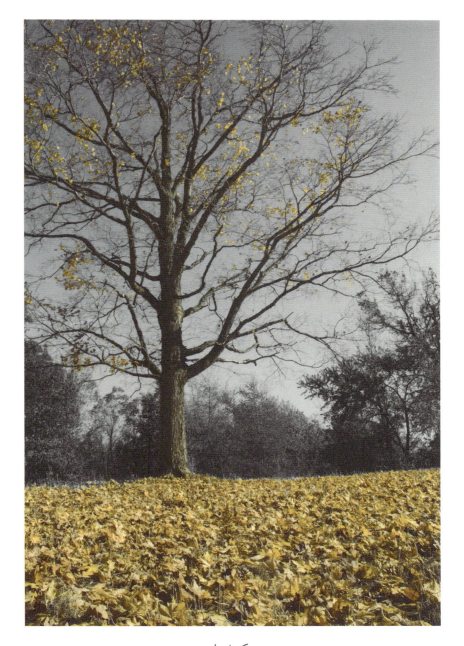

Let Go

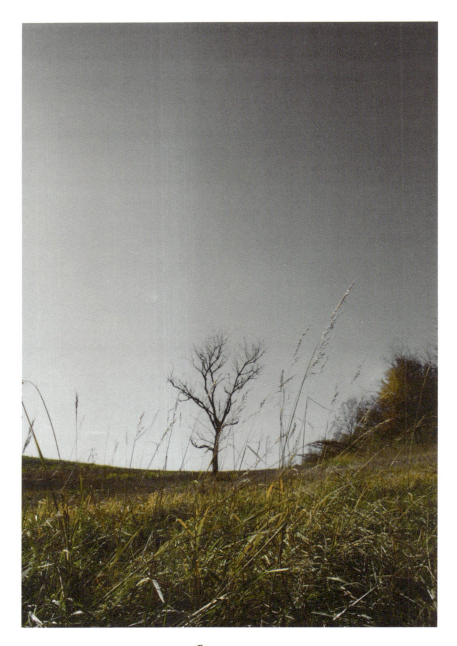

Barrenness

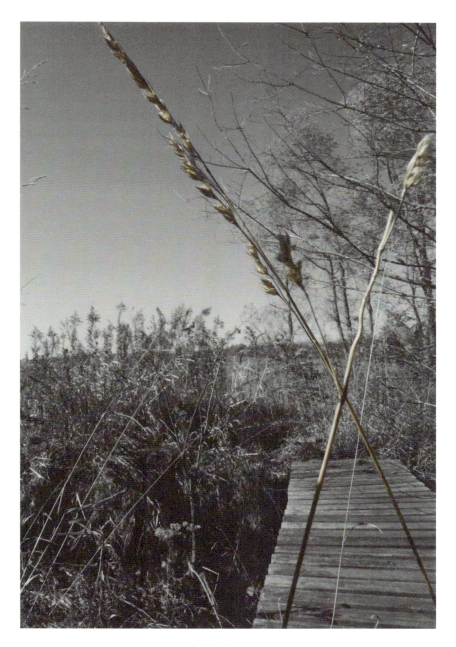

Path Keepers

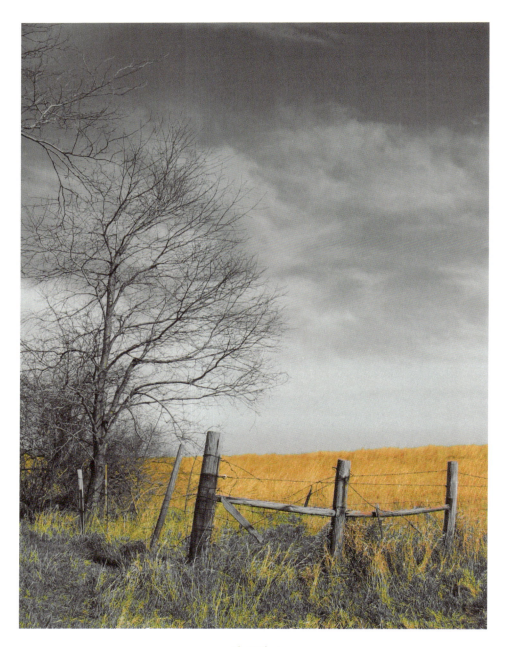

Untitled

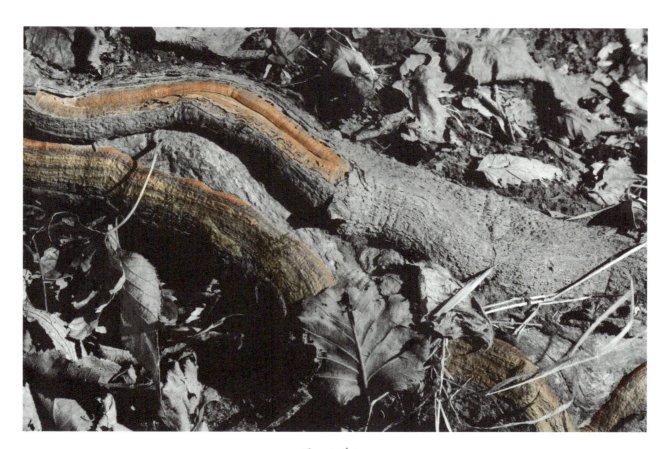

Root Veins

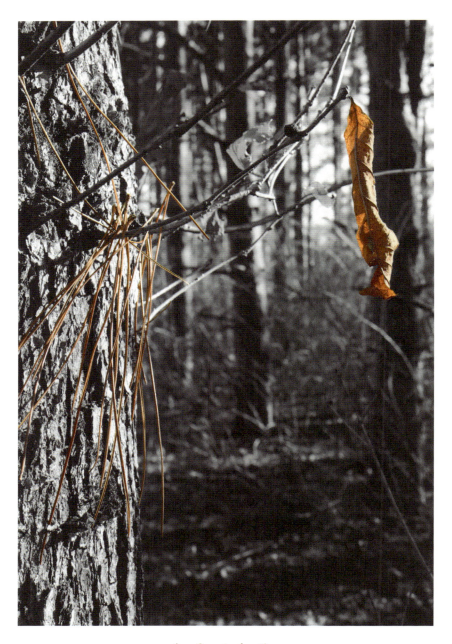

Leaf and Needles

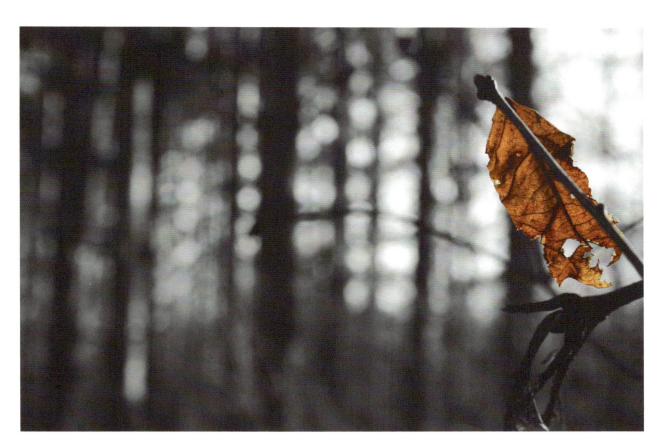

Battered Leaf

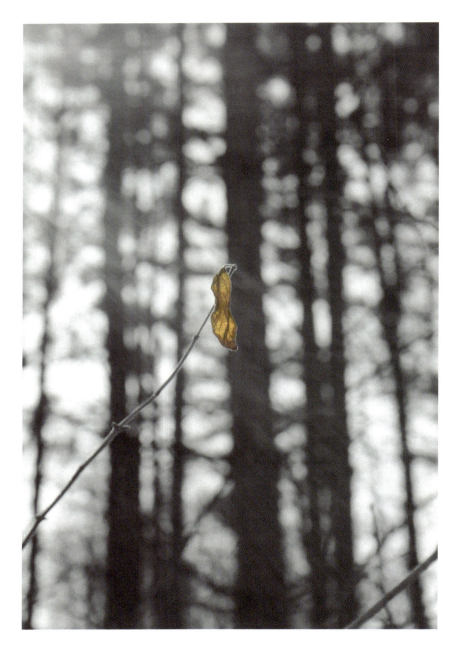

In Light

The creation of this book stems from no expertise on the subjects contained within. My hands never interacted directly with its foresight of preservation, reclamation of lands, or reseeding of forgotten inhabitants. All of the photographs were taken in a common location that was easily and often reached by a rickety old bicycle.

Dylan Punke

Dylan Punke is a self-learning photographer from the Bloomington-Normal area of Illinois. The works contained in Local Sanctuary and other works by Dylan can be found at his website:

www.dep-artgallery.com

All content in this work is copyrighted © Dylan Punke

Made in the USA
Charleston, SC
02 July 2011